magritte

mag

edited by David Larkin

ritte

introduction by Eddie Wolfram

BALLANTINE BOOKS · NEW YORK

WHEN I WAS A CHILD, a little girl and I used to play in the old disused cemetry of a provincial town. We would explore the vaults, whose heavy iron trapdoors we were able to lift, and would climb up again into the daylight, where an artist from the city would be painting in a picturesque walk with broken stone columns scattered among the dead leaves. It seemed to me then that the art of painting was vaguely magical and the painter endowed with superior powers.*

René Magritte describing some early memories; he was the kind of artist who

*MAGRITTE QUOTED IN LOUIS SCUTENAIRE, *René Magritte*, BRUSSELS, LIBRAIRIE SÉLECTION, 1947, p75.

would have been pleased to have met Alice through her looking-glass in a world where 'a place for everything and everything in its place' becomes a paradox – a seemingly absurd statement, or self-contradictory – but nevertheless still really founded on truth. His vision of the world was one in which the people around him, like Lot's wife, could quite easily turn into pillars of salt, where French bread could drift across starlit blue skies as light as clouds, and where real clouds were made of granite; where trees were leaves, and mountains yearned to fly like soaring eagles; where bowler-hatted commuters precipitated from clear skies like April showers, and locomotive express trains screamed out of open fireplaces; where shoes grew toes, and mermaids became practical, growing legs where their tails should be, in exchange for gills where their breasts once were: a painter of visual riddles, which on first impression appear to be simply born out of the chance encounter between unrelated objects. In the skilful hands of Magritte, illogical ideas, hitherto unconnected in the mind, are opened up with new meanings which had been hidden, lost and forgotten through over-familiarity with things which we just take for granted. The work of René Magritte acts as an antidote for the old adage that familiarity always breeds contempt. The artist describes how some of his paintings came to be made:

As for the locomotive, I made it loom out of a dining-room fireplace in place of the usual stovepipe. This metamorphosis is called *La Durée Poignardee/Time Transfixed* (plate 40). *L'Invention Collective/Collective Invention* (plate 12) is the answer to the problem of the sea: lying on the beach is a mermaid whose top half is that of a fish and bottom half the belly and legs of a woman... *Le Domaine d'Arnheim/The*

Domain of Arnheim (plate 30) is the realization of a vision that would have much pleased Edgar Allan Poe: an immense mountain shaped exactly like an eagle with wings spread. It is seen through an opening with a ledge on which there are two eggs ... Woman gave rise to *Le Viol/The Rape* (plate 2). This is a woman's face made up of her body. The breasts are the eyes, the nose is the navel and her sex replaces the mouth.
The problem of shoes demonstrates how the most barbarous things can appear perfectly decent through force of habit. Thanks to *Le Modèle Rouge/The Red Model* (plate 7), the conjunction of a human foot and a leather shoe can in fact be . traced back to a monstrous practice. The problem of 'the window' led to *La Condition Humaine/The Human Condition* (plate 14). In front of a window seen from inside a room I placed a picture representing exactly that part of the landscape which was masked by the picture. In this way the tree represented in the picture hid the tree standing behind it, outside the room. For the spectator the tree was at one and the same time in the room — in the picture — and, by inference, outside the room — in the real landscape. This is how we see the world; we see it outside ourselves and yet we have only a representation of it within us. In the same way we sometimes situate in the past a thing which is happening in the present. So time and space are freed from the crude meaning which is the only one allowed to them in everyday experience.*

To look at a Magritte painting is to see through the barrier of time. The present becomes no more real now than the memory of what has passed; and hopes, which are our only idea of the future, become less desperate, since all the dimensions of time in a painting by Magritte are interchangeable. The result

*OP.CIT.P.82-4.

is that the status quo of objects and reality itself can now be understood as negotiable: merely a transitory experience.

'To me a picture is a window that looks out on something, the question is — on what?' This time the words belong to Andre Breton, poet and formulator of the Surrealists' ideal; and the meaning behind the question relates more aptly to the paintings of Magritte than any other surrealist painter. With the exception of the brief period of FAUVE-impressionist paintings that he made in the war years of the early forties, Magritte's paintings have always remained windows that look out on something that is recognisable as part of the real world, yet the question they always ask is — what? Whether brought together by mere chance or premeditation it is clear from his own words that the objects that Magritte assembles always amount to a much more profound relationship than just haphazard or

arbitrary encounters. But despite Breton's apt question it was not long before Magritte lost sympathy with the hard line of the other Surrealists. A reclusive and quiet man by temperament, he loathed intellectualizing about the meaning of his paintings, preferring to gather his inspiration directly from nature, from the world of real objects and places around him, not wishing to destroy the magic he found in these encounters by quasi-Freudian verbal analysis.

'Any conscious, mental control of reason, taste, will, is out of place in a work that deserves to be described as absolutely surrealist,' is how that other great surrealist artist Max Ernst summed up his own attitude, quite different from that of Magritte. Magritte did use reason, taste and will consciously, pragmatically, as it suited him to make his pictures. To this degree, Magritte was not an absolute Surrealist. He was never prepared to allow

absolute freedom to the subconscious impulse, like Dali chasing his dreams or Miro exploring free and autonomous abstract forms.

Breton wrote, 'I shall not conceal that for me the strongest surrealist image is the one that pursues the highest degree of the arbitrary, the one that takes the longest to translate into practical language, whether it contains an enormous amount of apparent contradiction; whether promising to be sensational, it seems to come to a weak conclusion; whether it draws from itself a derisory formal justification; whether it is of a hallucinatory nature; whether it lends very naturally the mask of the concrete to abstraction or vice versa; whether it implies the negation of some elementary physical quality; or whether it provokes laughter.'

For Magritte, this dogmatically committed insistance on total creative surrender to the libido drive and the id always remained an over-simplification. He would probably have preferred to side with the mad March Hare: "You might as well say," added the March Hare, "that 'I like what I get' is the same thing as 'I get what I like'!"

In terms of how he saw life, Magritte liked what he saw around him to work with to make his art. He was born in Lessines in the province of Hainault in 1898 and with the exception of visits abroad, notably a three year stay in Paris from 1927-30 (the important years for surrealism there), he lived most of his life in his native Belgium in an obscure suburb of Brussels. Seemingly an ordinary man in an ordinary house, he chose to live with an unassuming identity, shunning the intellectual and artistic life of the capital. And, in the thirties, while the other Surrealists were beginning to explore

automatism, their own paranoia or dreams, Magritte went his own individual way, working with direct reference to the world about him and its objects. His concern was to reveal its secret meanings by a variety of representations that was always 'realistic' yet nevertheless poetic. For him the act of painting was a means of knowing life better and at the same time liberating things from their familiar roles in everyday life. Through this apparently simple act of liberation he was able to uncover mysteries. Magritte's paintings are always windows looking out on life, but with the logic of time and place set aside to reveal the innermost nature of things, and the discovery of this can be an unnerving experience.

I am repatriated by a moment of panic. These are the privileged moments that transcend mediocrity. But for that there doesn't have to be art — it can happen at any moment. If one looks at a thing with the intentions of trying to discover what it means, one ends up no longer seeing the thing itself, but thinking of the question that has been raised. One cannot speak about mystery; one must be seized by it.*

Magritte's paintings seize the mind's eye of the spectator through their mystery.

There is a secret affinity between certain images; it is equally valid for the objects which those images represent . . . We are familiar with birds in cages; interest is awakened more readily if the bird is replaced by a fish or a shoe: but though these images are strange they are unhappily accidental, arbitrary. It is possible to obtain a new image which will stand up to examination through having something final, something right about it: it's the image showing an egg in a cage.*

In such an instance Magritte would

*MAGRITTE IN SUZI GABLIK, 'A CONVERSATION WITH RENE MAGRITTE', *Studio International*, VOL. 173, NO. 887, LONDON, MARCH 1967, P. 128.

*MAGRITTE IN SCUTENAIRE, OP. CIT., P. 38.

forgive us crying out with alarm, along with the Queen of Hearts, 'He's murdered the time! Off with his head!' Without unnecessary Freudian underwriting Magritte has the knack of touching the roots of the collective subconscious, bringing home to us once more nearly-forgotten truths about the absurdities and contradictions in reality. It is in the shock of these realizations, when we see that the egg is also the bird before it is born, that his pictures possess the power to disturb us. In this instance he clearly postulates the absurdity of the assumptions we make about time and place: and as in his art, so in his life, even able to anticipate our outrage at finding him out by disguising his own identity amid the anonymity of those countless faceless men in their bowlers. They hide their faces behind apples or simply turn their backs upon us. In one such portrait he has even left a void between the white collar and the hat; the face which should fill the void, just like the grin of the Cheshire Cat, already just floats in space to one side.

Magritte chose the role of an unassuming spectre: he preferred the paintings to speak for themselves. Yet he was an artist who knew precisely what he wanted, or even more precisely what he didn't want.

The other day someone asked me what is the relationship between my life and my art. I couldn't really think of any, except that life obliges me to do something, so I paint. I do not believe that man decides anything – either the future or the present of humanity. A universe of chances? I don't know. Unknown forces? I hate talking about that because it doesn't mean anything. I think we are responsible for the universe, but this does not mean that we decide anything. Cause and effect? That's determinism, and there again, one would have to believe in it. If one is a

determinist, one must always believe that there is a cause which produces some effect. I am not a determinist but I don't believe in chance either. It serves as another 'explanation' of the world. The problem lies precisely in not accepting any explanation of the world either through chance or determinism. I am not responsible for my belief. It is not even I who decided that I am not responsible – and so on to infinity. I am not obliged to believe. There is no point of departure.*

It seems to me that Magritte is best appreciated as a painterly Lewis Carroll, who created a Wonderland for adults; or, for a world in which human relationships and personality are becoming increasingly invaded by the iniquitous cancer of behavioral conformity, spawned by the industrial age and now escalated by the computer. Progress may not be stopped; it offers no options, except for the Medicare of the mass media's soap operas, the delusions of nostalgia. Unlike so many lesser artists, Magritte refused the solicitations of the numerous pseudo-innovations thrown up by the rapid march of progress, where only novelty is deemed worth chasing. Yet neither did he become entrenched in any useless rearguard action futilely attempting to resurrect the past. Gauguin asserted the right to 'dare anything.' Magritte asserted the right to remain inscrutably himself. 'You may call it nonsense if you like,' said the Red Queen, 'but I've heard nonsense, compared with which that would be as sensible as a dictionary.'

EDDIE WOLFRAM

*MAGRITTE IN GABLIK, LOC. CIT., P. 129.

magritte

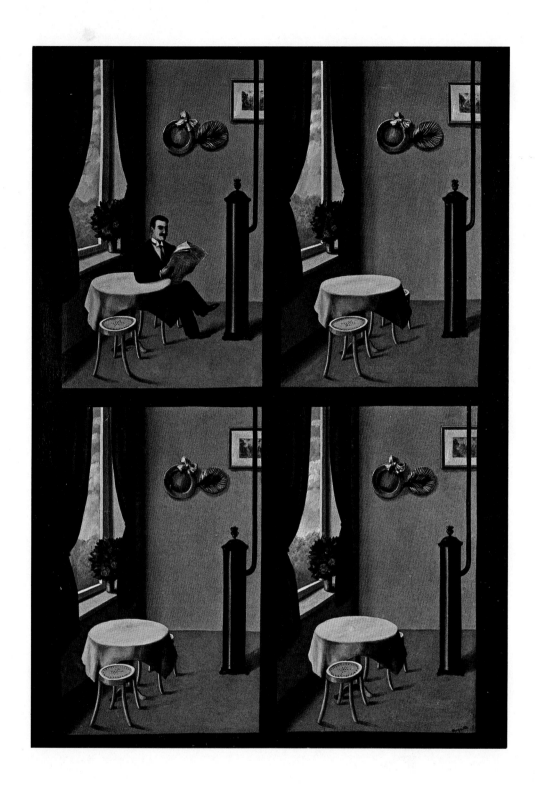

1) L'Homme au journal (Now, you don't) 1927 TATE GALLERY, LONDON

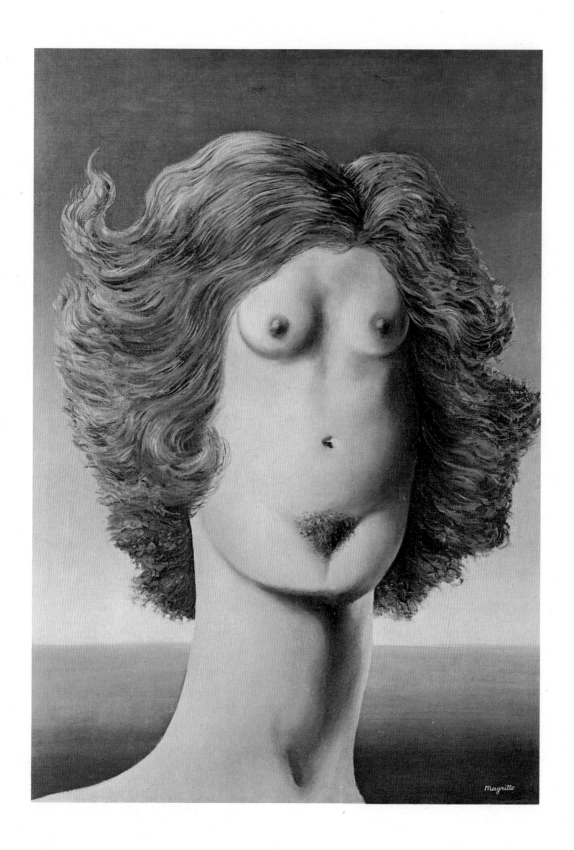

2) Le Viol (The rape) 1934 GEORGE MELLY COLLECTION, LONDON

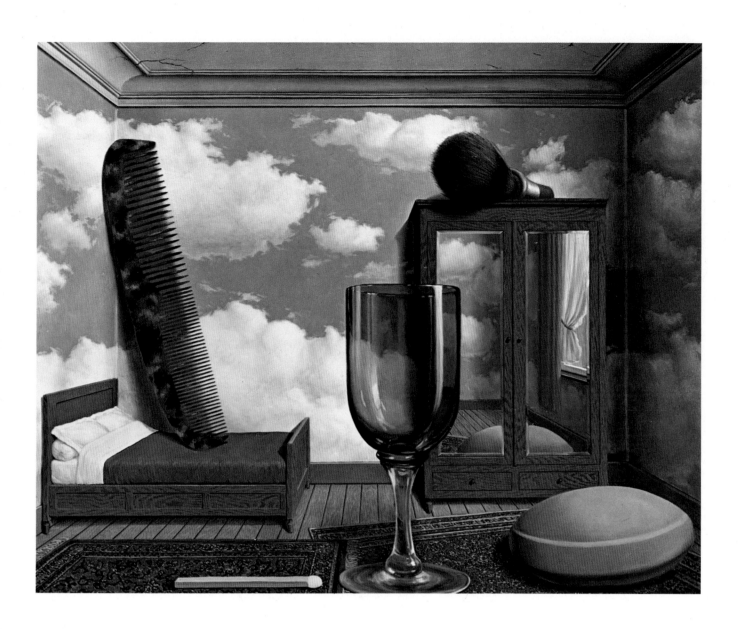

3) Les Valeurs personnelles (Personal values) 1952 PRIVATE COLLECTION, YORKTOWN, NEW YORK

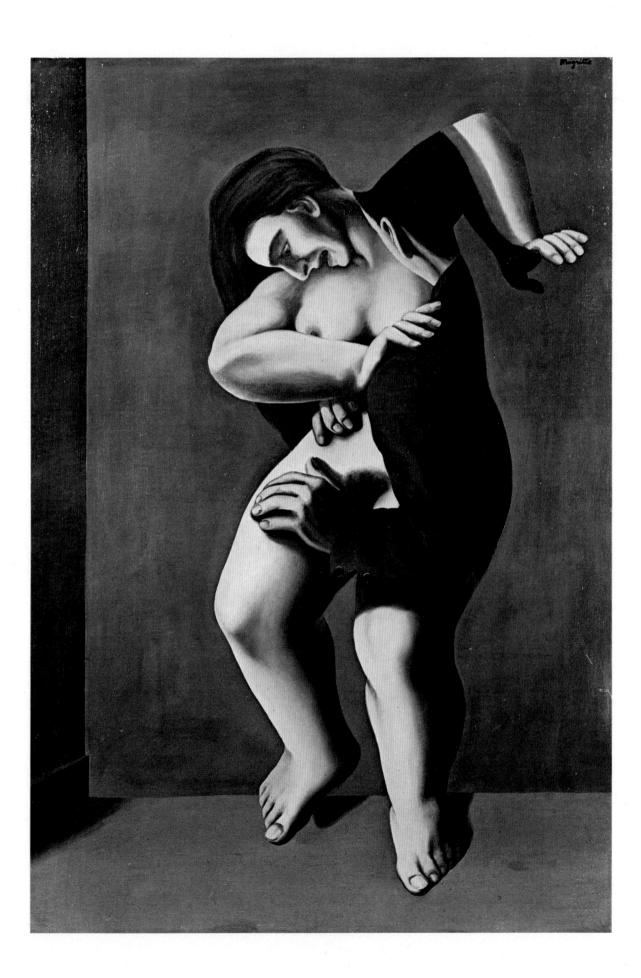

4) Les Jours gigantesques (The titanic days) 1928 PRIVATE COLLECTION, BRUSSELS

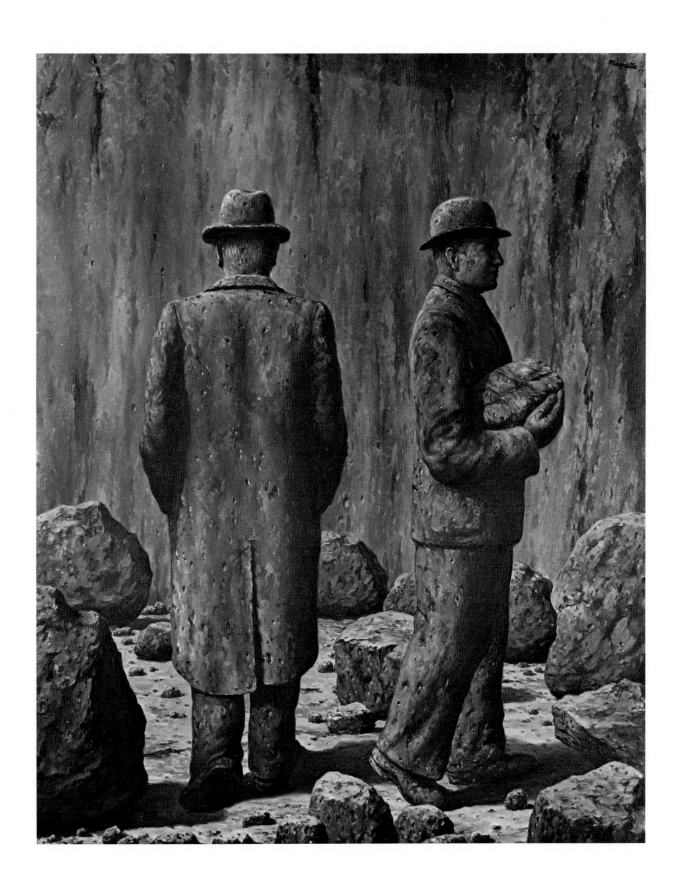

5) Le Chant de la violette (The song of the violet) 1951 PRIVATE COLLECTION, BRUSSELS

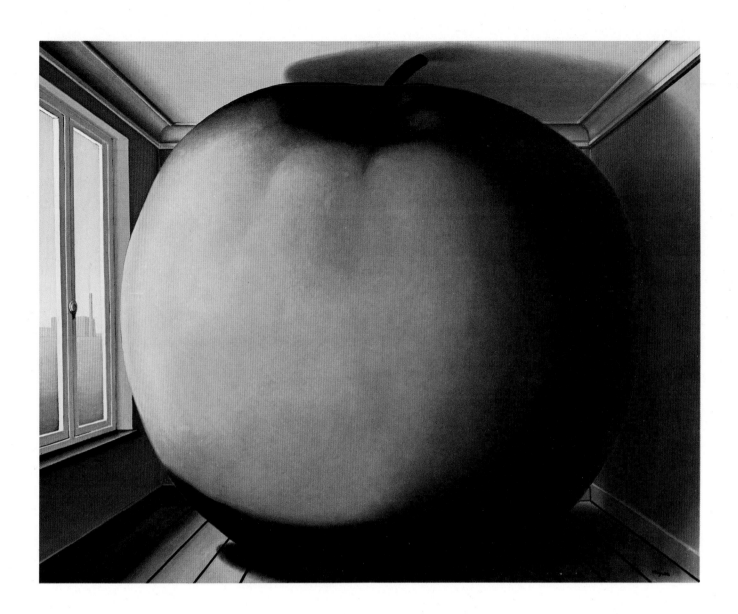

6) La Chambre d'écoute (The listening room) 1953 PRIVATE COLLECTION

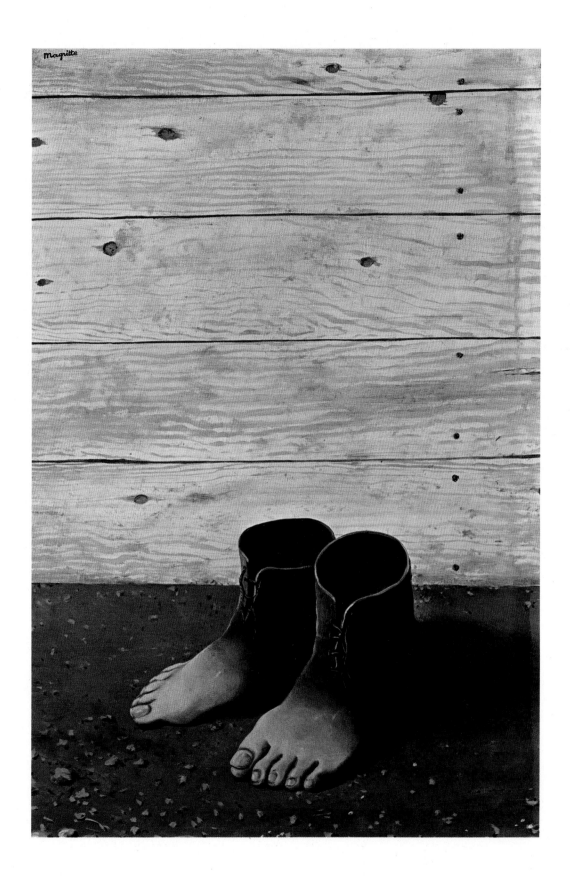

7) Le Modèle rouge (The red model) 1935 MODERNA MUSEET, STOCKHOLM

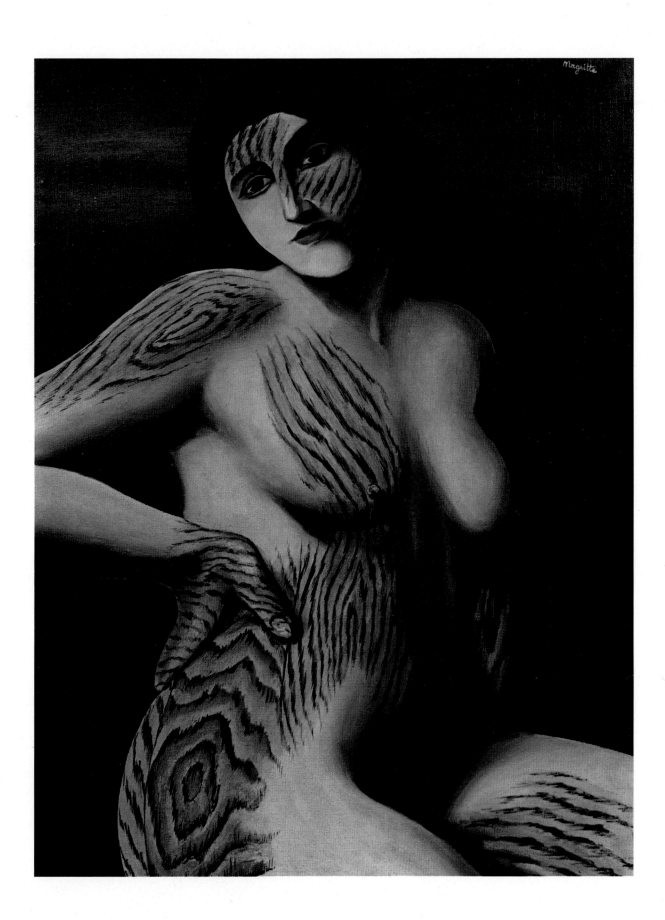

8) Découverte (Discovery) 1927 SCUTENAIRE COLLECTION, BRUSSELS

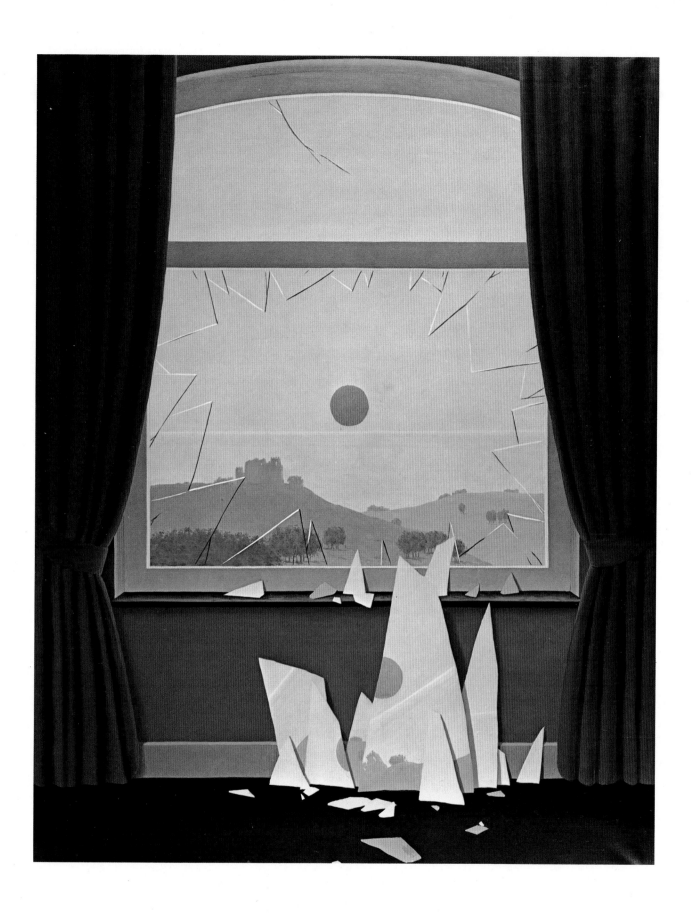

9) Le Soir qui tombe (Evening falls) 1964 PRIVATE COLLECTION

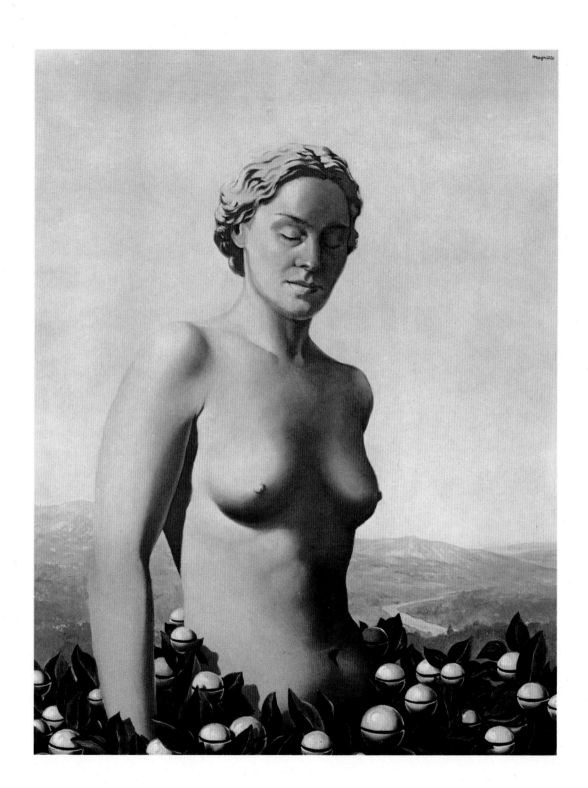

10) Magie noire (Black magic) SPAAK COLLECTION, FRANCE

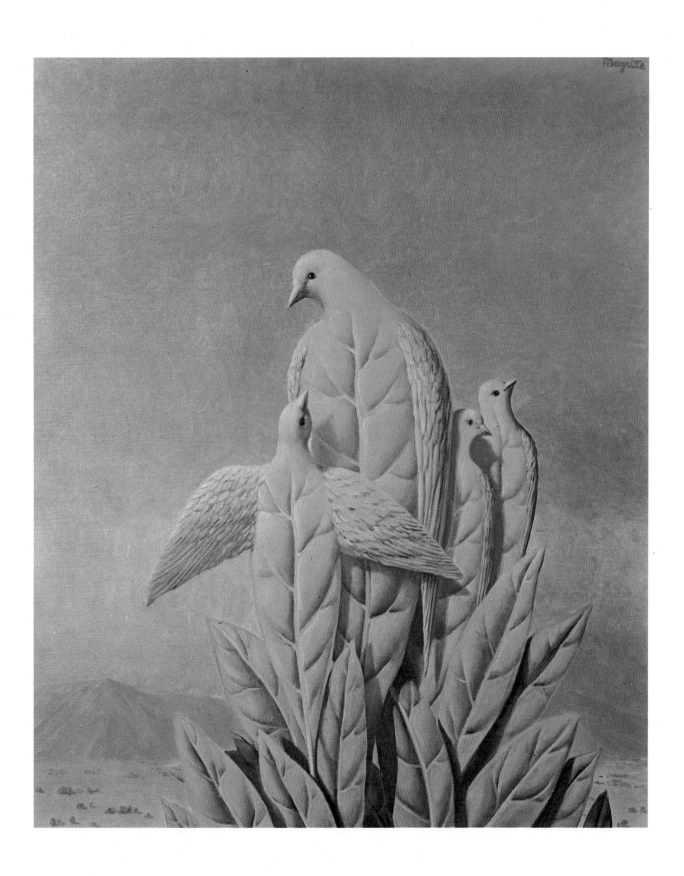

11) Les Grâces naturelles (The natural graces) 1963 P SCHEIDWEILER COLLECTION, BRUSSELS

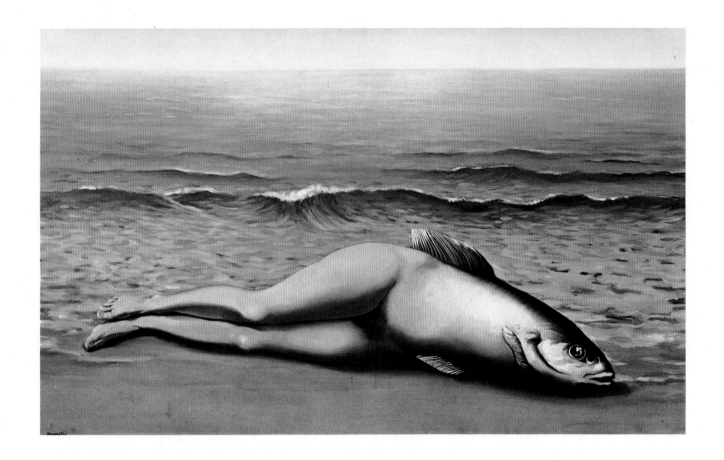

12) L'Invention collective (Collective invention) 1935 PRIVATE COLLECTION, BELGIUM

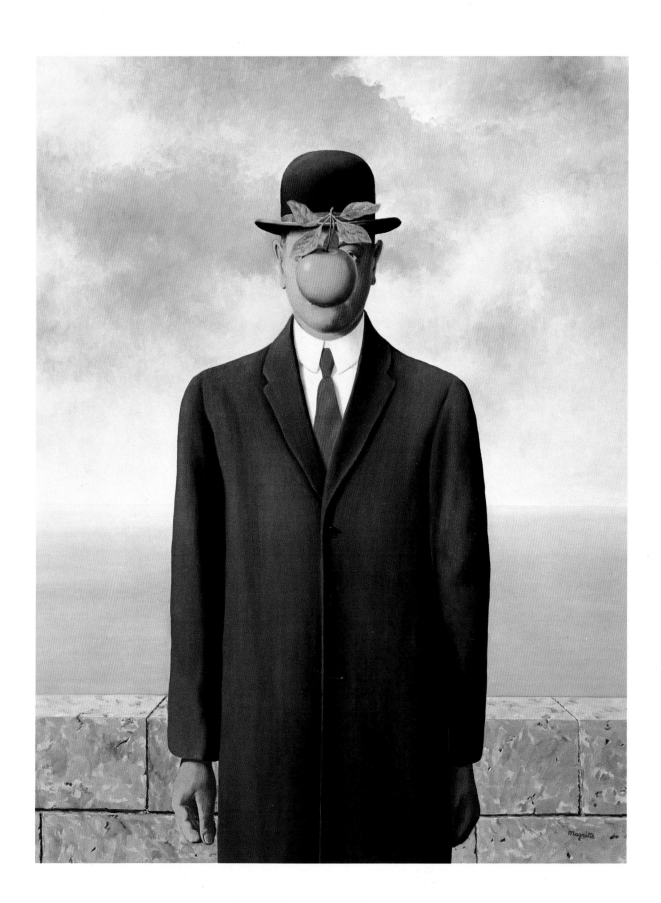

13) Le Fils de l'homme (The son of man) 1964

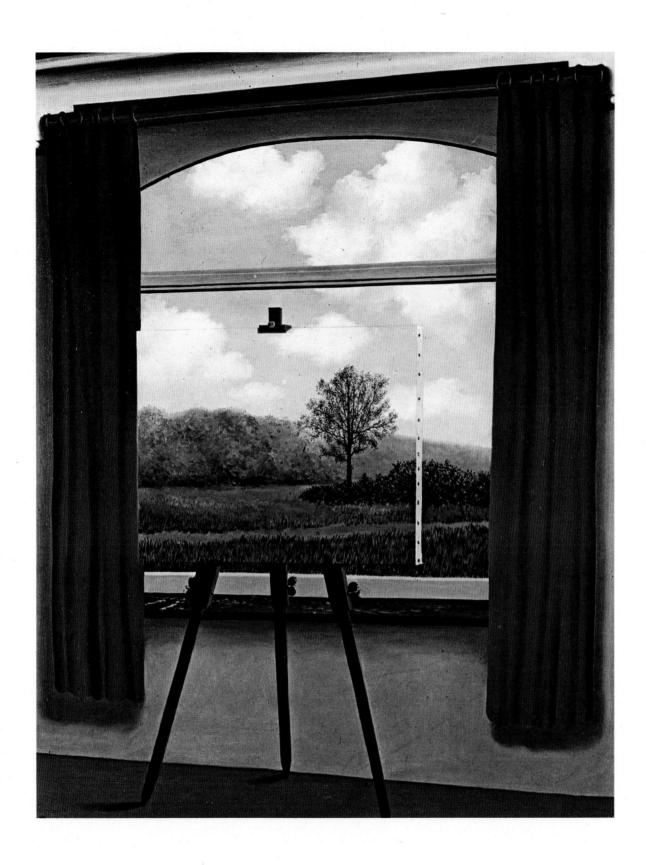

14) La Condition humaine I (The human condition I) 1933 SPAAK COLLECTION, FRANCE

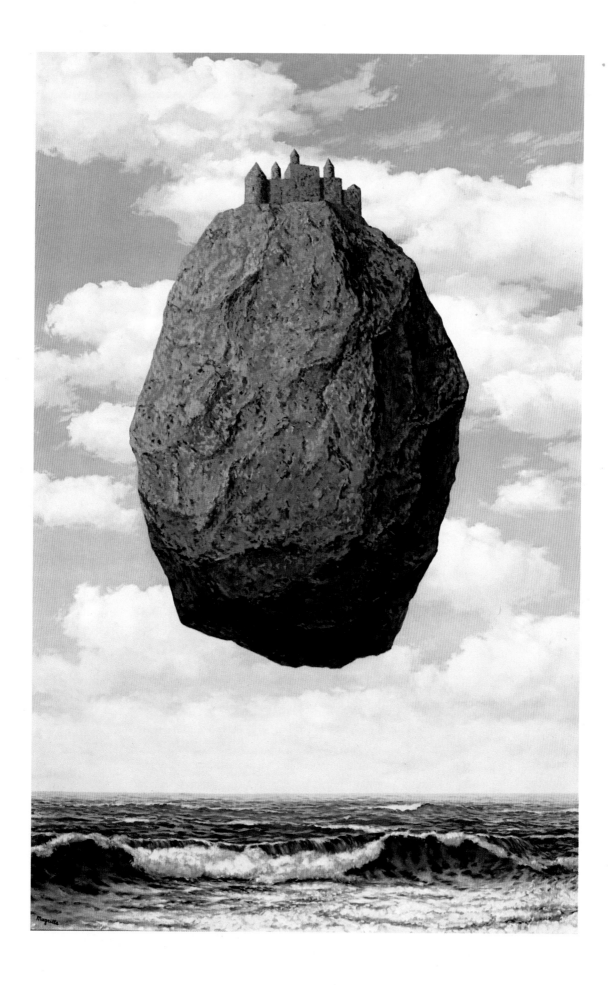

15) Le Château des Pyrénées (The castle of the Pyrenees)
HARRY TORCZYNER COLLECTION, NEW YORK

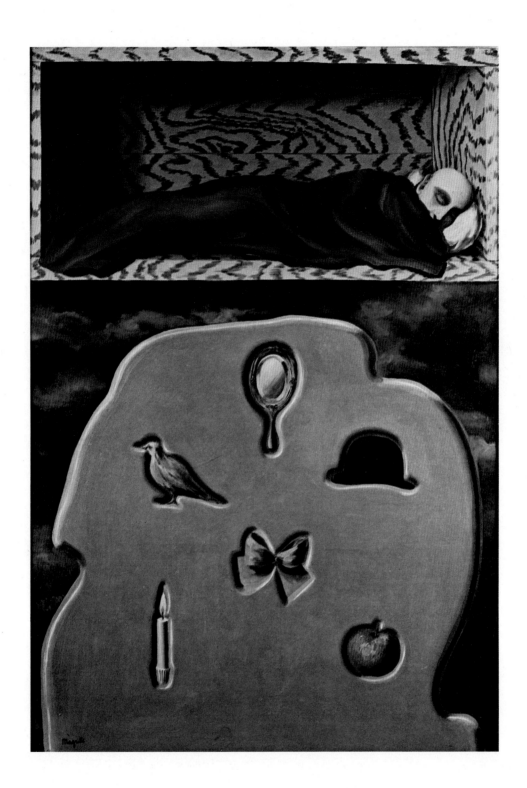

16) Le Dormeur téméraire (The reckless sleeper) 1927

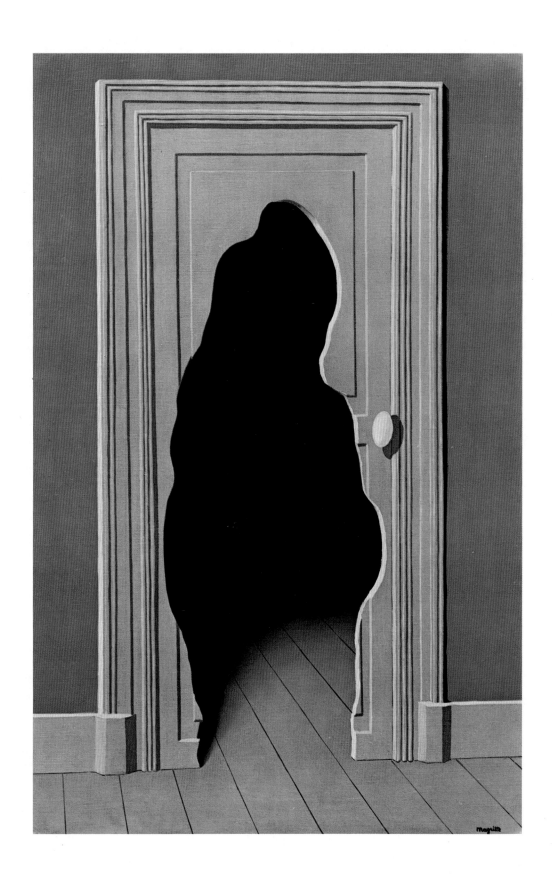

17) La Réponse imprévue (The unexpected answer)
1933 MUSEES ROYAUX DES BEAUX ARTS DE BELGIQUE, BRUSSELS

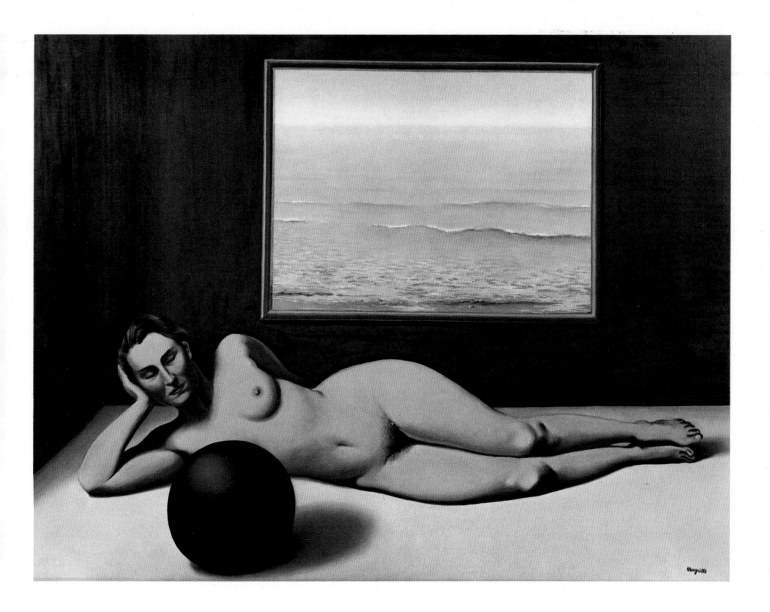

18) La Baigneuse du clair au sombre (Bather between light and darkness) 1935

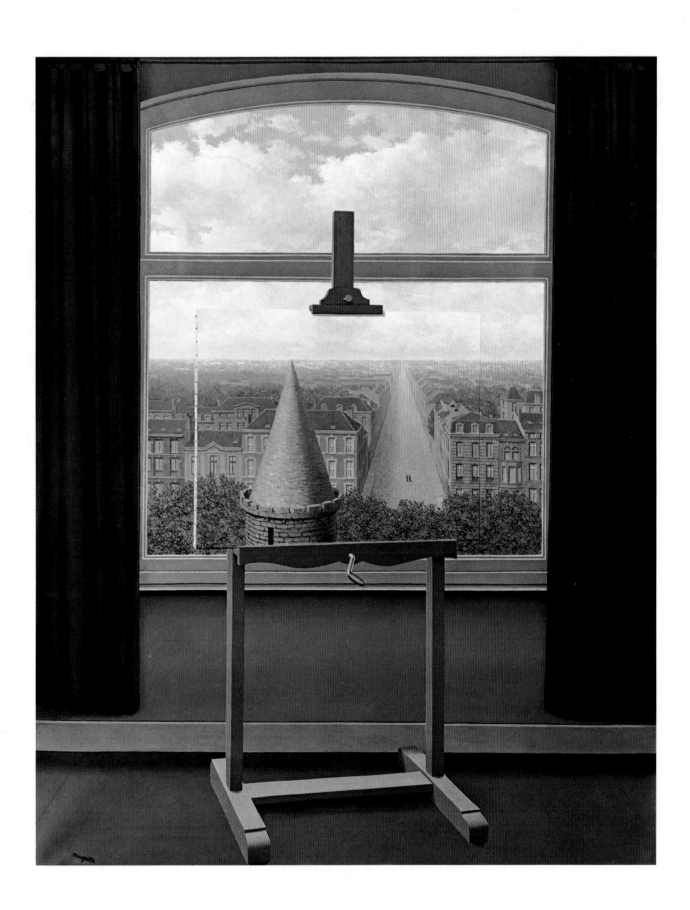

19) Les Promenades d'Euclide (Euclidean walks)
1955 THE MINNEAPOLIS INSTITUTE OF ART

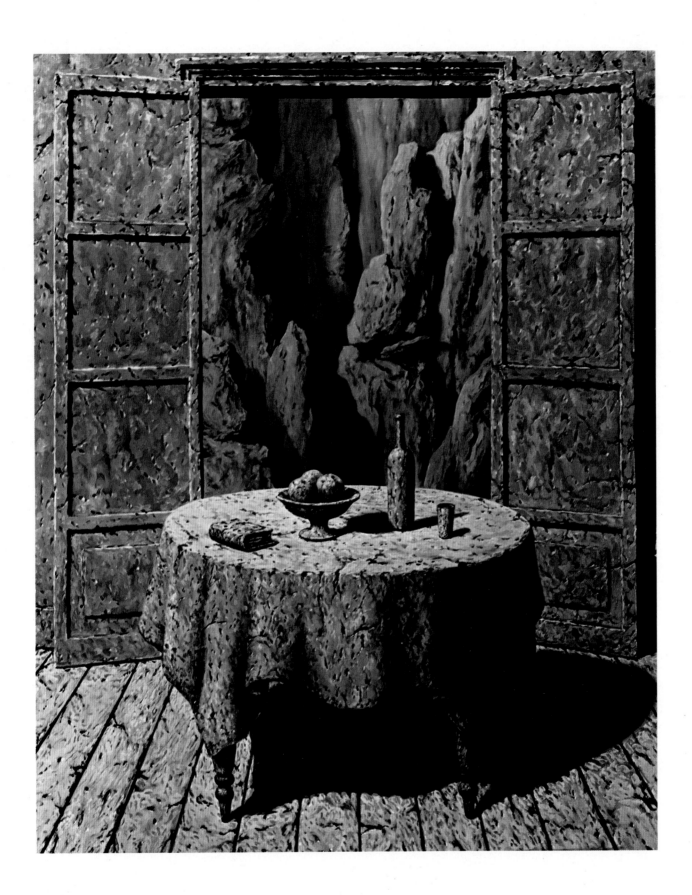

20) Souvenir de voyage III (Memory of a journey III)
1951 ADELAIDE DE MENIL COLLECTION, NEW YORK

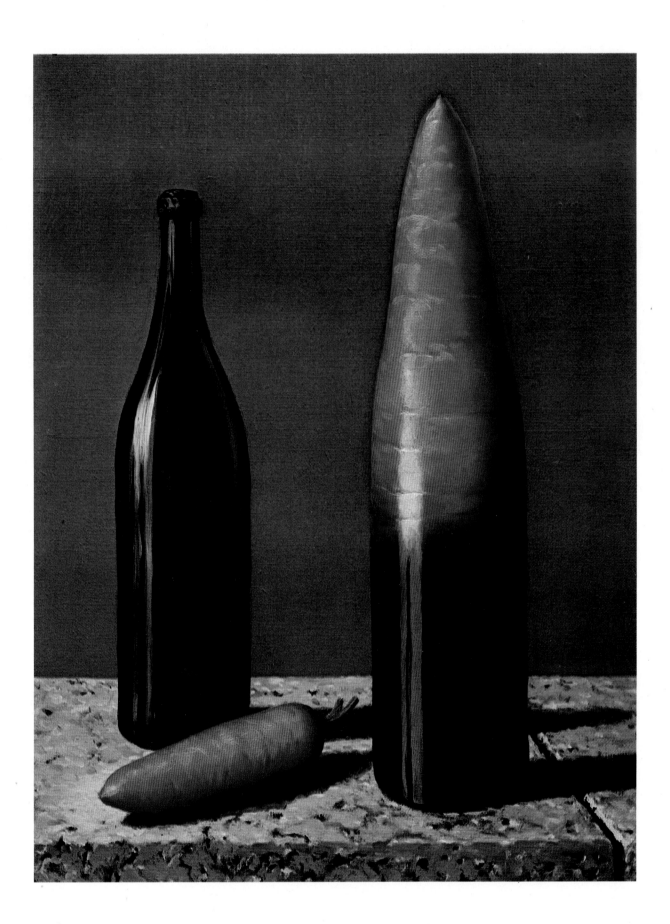

21) L'Explication (The explanation) 1952

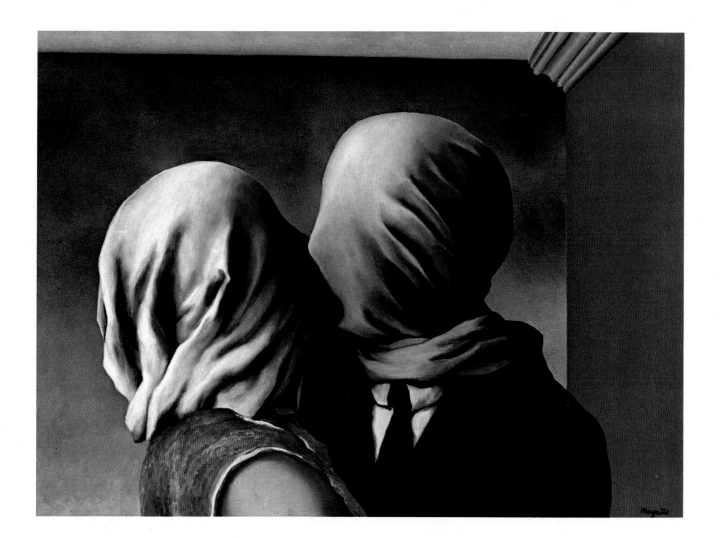

22) Les Amants (The lovers) ZEISLER COLLECTION, NEW YORK

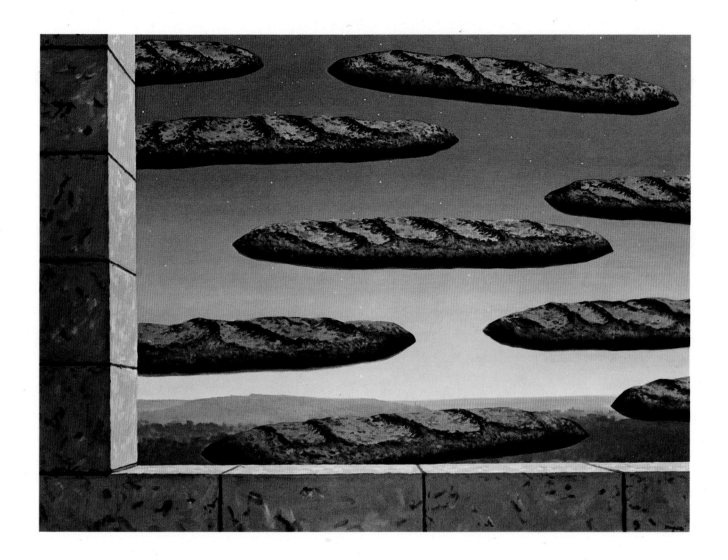

23) La Légende dorée (The golden legend) 1958 PRIVATE COLLECTION, YORKTOWN, NEW YORK

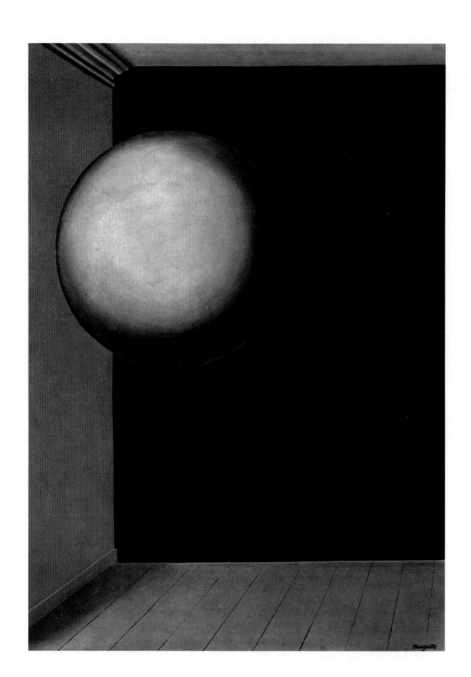

24) La Vie secrète IV (The secret life IV) 1928 PRIVATE COLLECTION, GENEVA

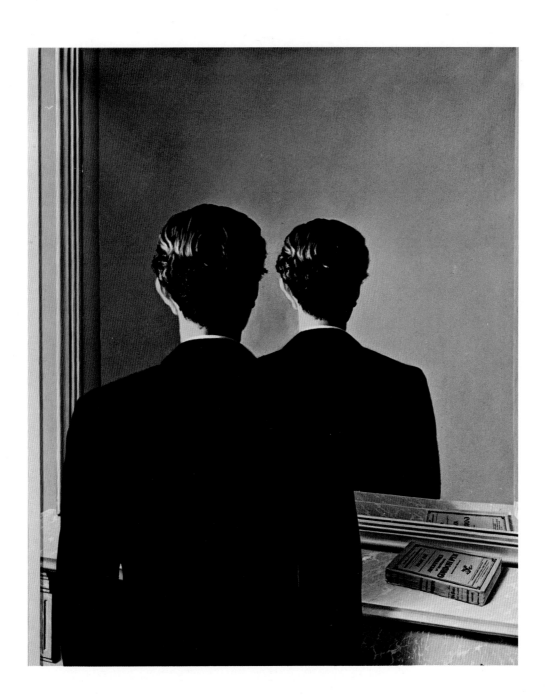

25) La Reproduction interdite (Not to be reproduced)
1937 EDWARD JAMES FOUNDATION, ENGLAND

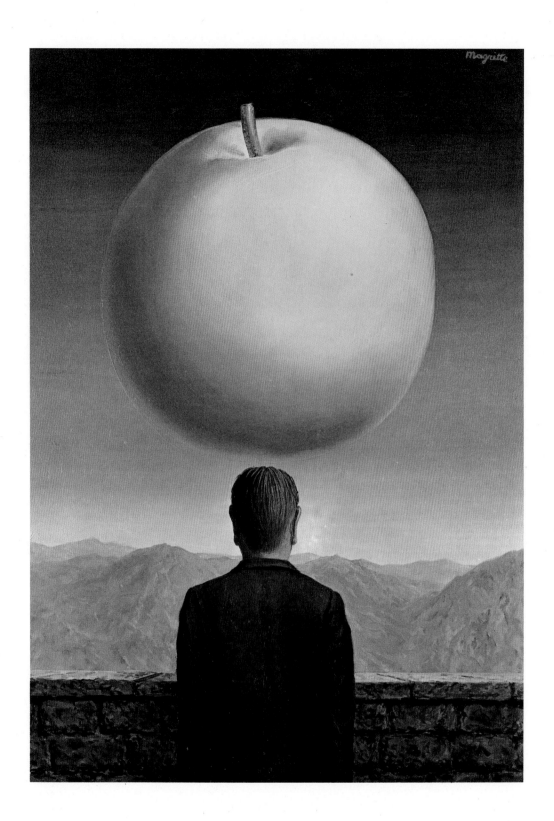

26) La Carte postale (The post card) PRIVATE COLLECTION, LONDON

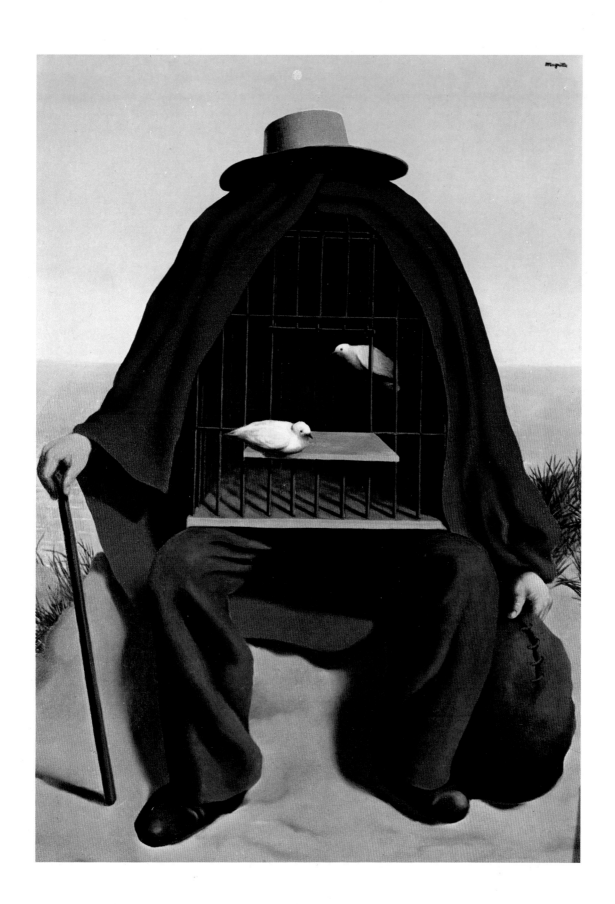

27) Le Thérapeute (The therapeutist) 1937 URVATER COLLECTION, PARIS

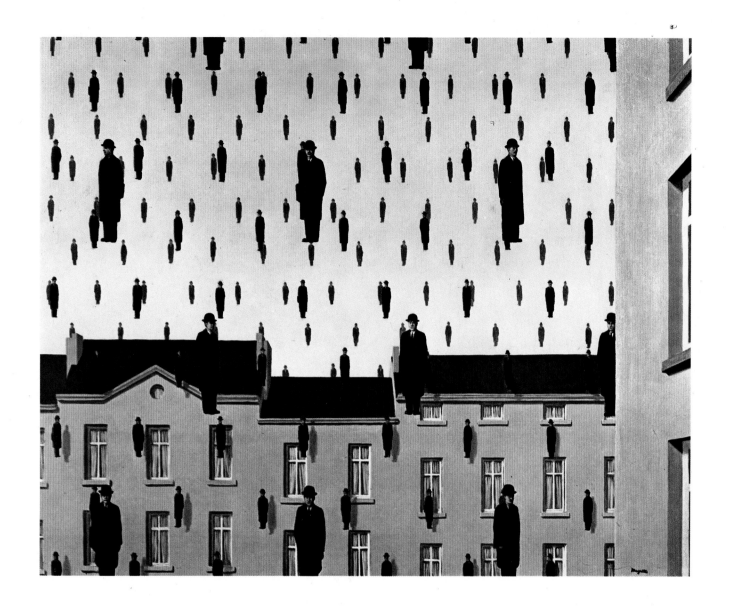

28) Golconda (Golconda) 1953 PRIVATE COLLECTION

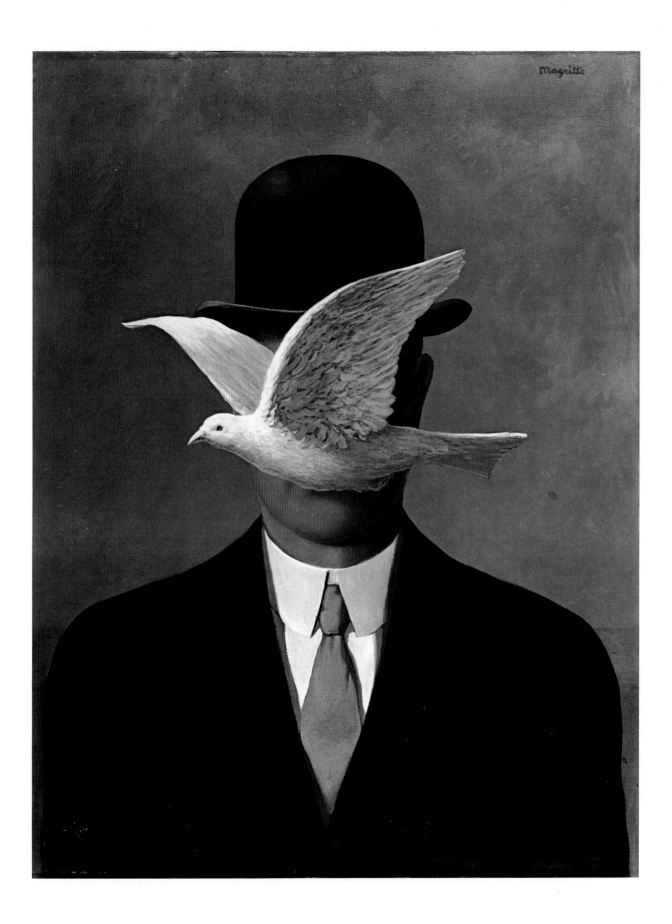

29) L'Homme au chapeau melon (The man in the bowler hat) 1964 SIMONE WITHERS SWAN COLLECTION, NEW YORK

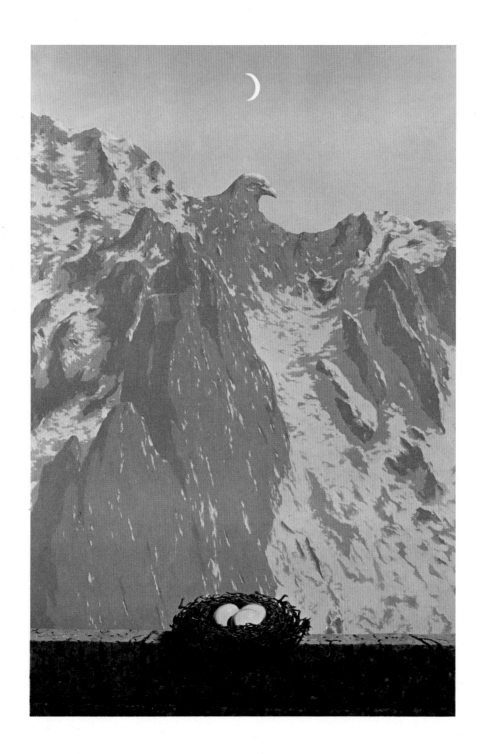

30)	Le Domaine d'Arnheim (The domain of Arnheim)	1962	MRS MAGRITTE COLLECTION, BRUSSELS

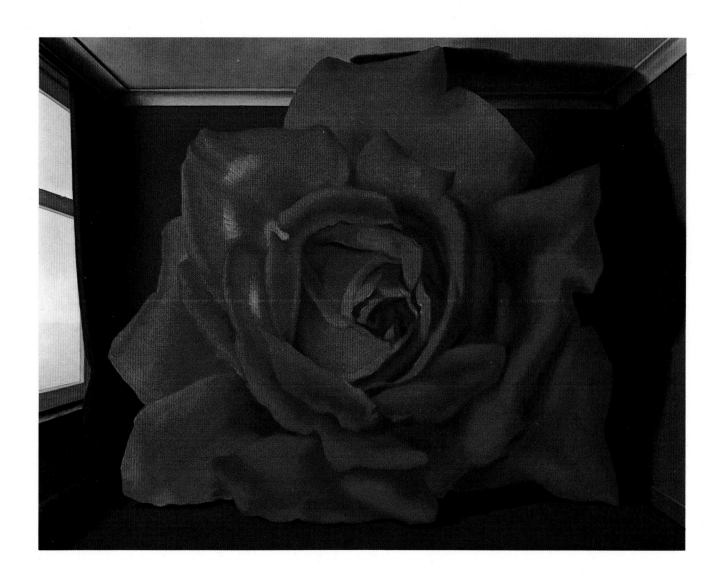

31) Le Tombeau des lutteurs (The wrestler's tomb) 1960 PRIVATE COLLECTION, YORKTOWN, NEW YORK

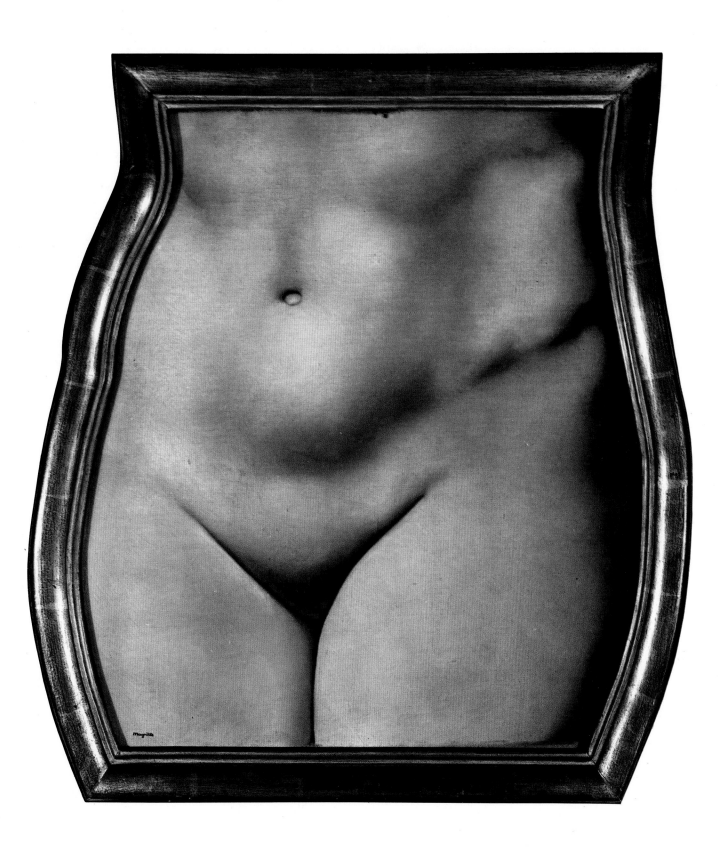

32) La Représentation (Representation) 1937 PENROSE COLLECTION, LONDON

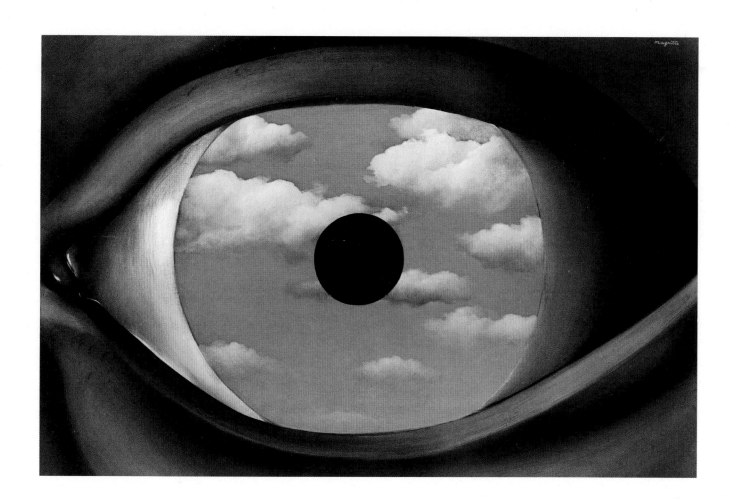

33) Le Faux Miroir (The false mirror) 1928 MUSEUM OF MODERN ART, NEW YORK

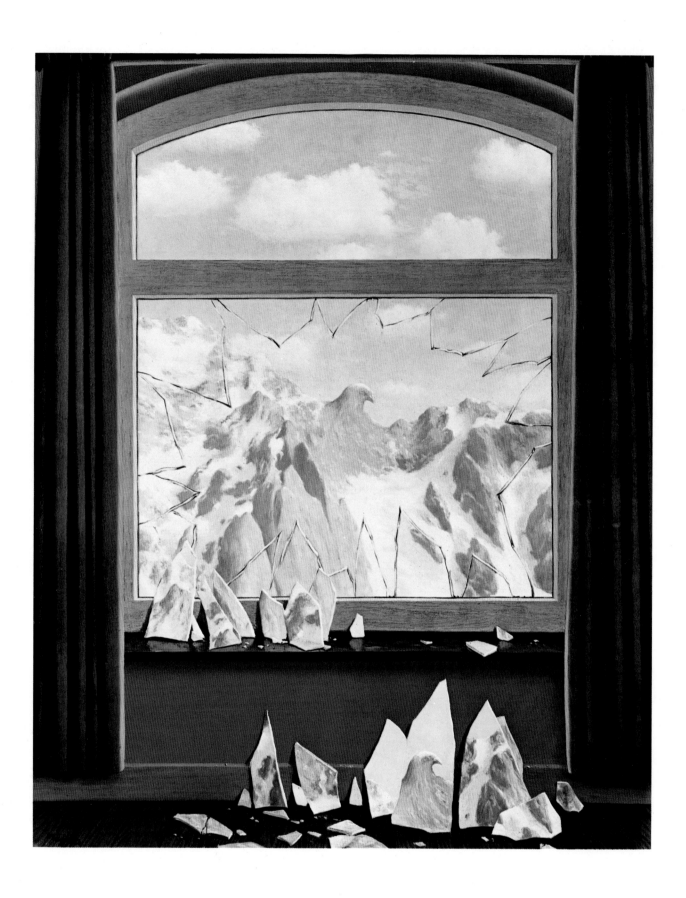

34) Le Domaine d'Arnheim (The domain of Arnheim) 1949 PRIVATE COLLECTION, U S A

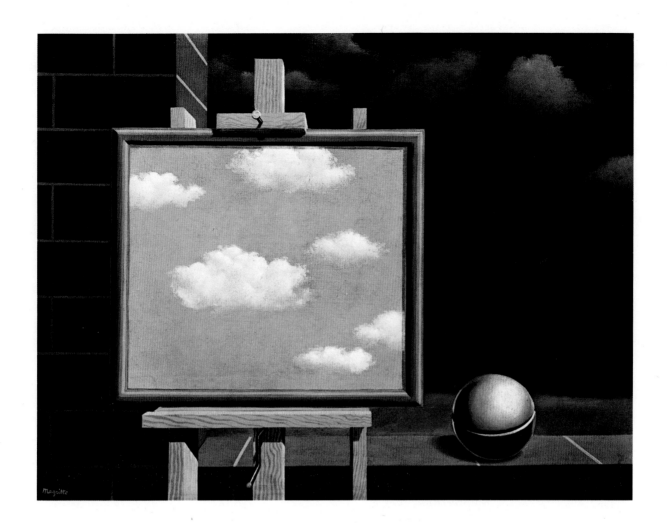

35) La Révolution (The Revolution) PRIVATE COLLECTION, LONDON

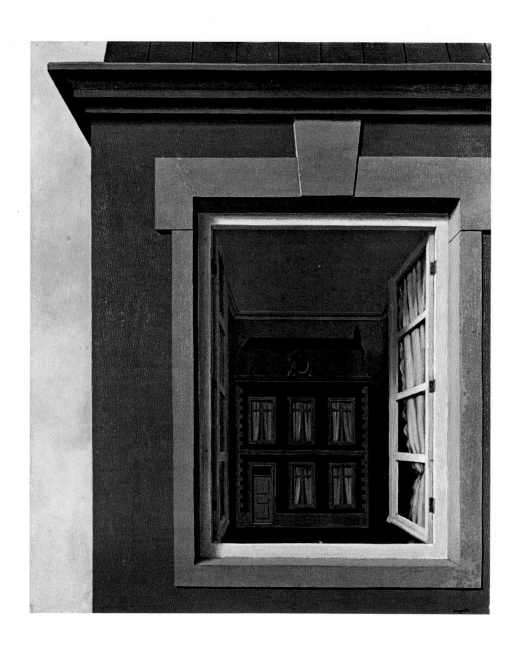

36) L'Eloge de la dialectique (In praise of dialectic) 1937 NATIONAL GALLERY OF VICTORIA, MELBOURNE

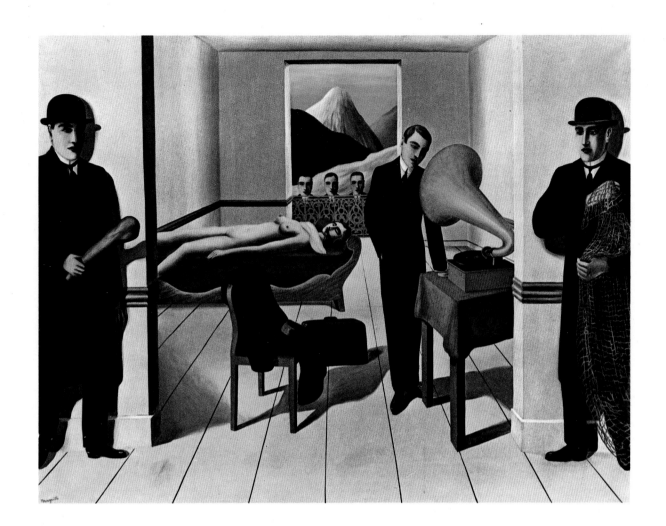

37) L'Assassin menace (The menaced assassin) 1926 THE MUSEUM OF MODERN ART, NEW YORK

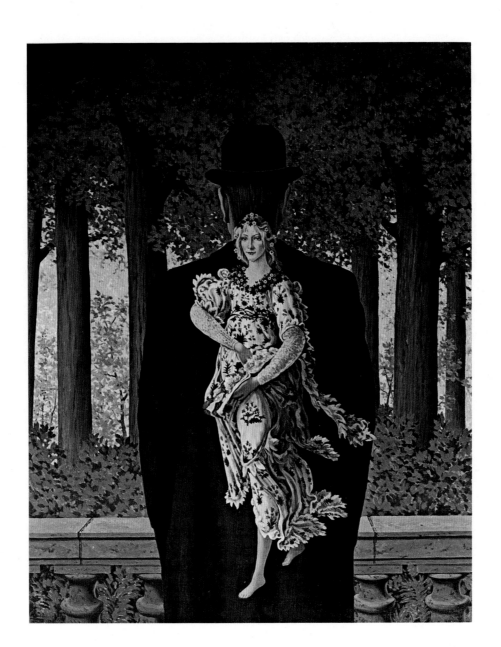

38) Le Bouquet tout fait (Ready-made bouquet) 1957 MR AND MRS BARNET HODES, CHICAGO

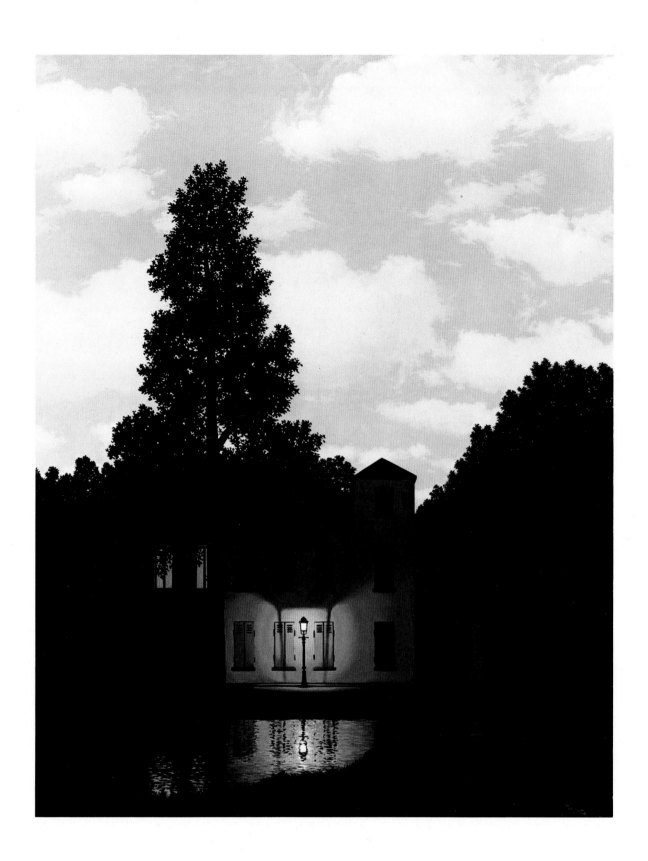

39) L'Empire des lumières II (The empire of light II) 1950 MUSEUM OF MODERN ART, NEW YORK

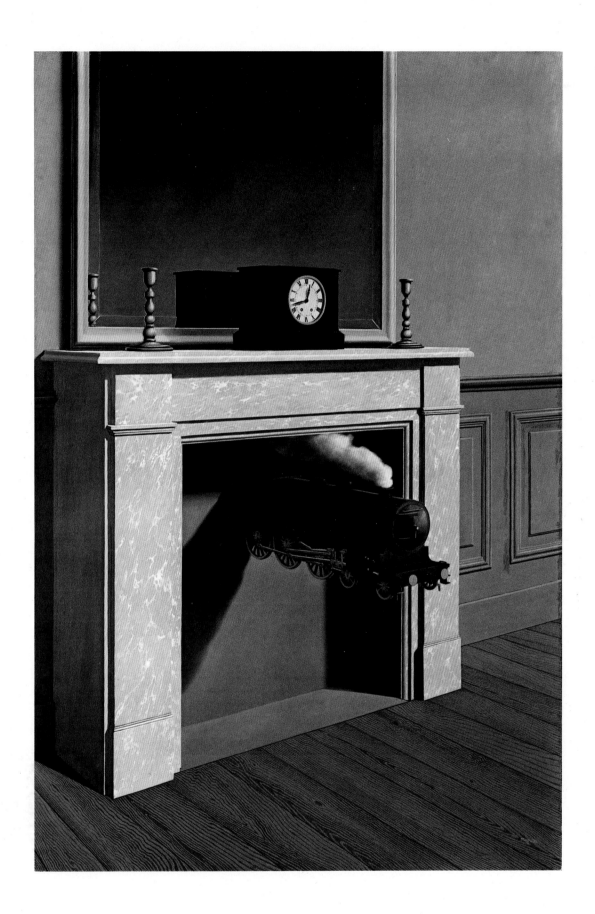

40) La Durée poignardée (Time transfixed) 1939 THE ART INSTITUTE OF CHICAGO